APERTURE MASTERS OF PHOTOGRAPHY

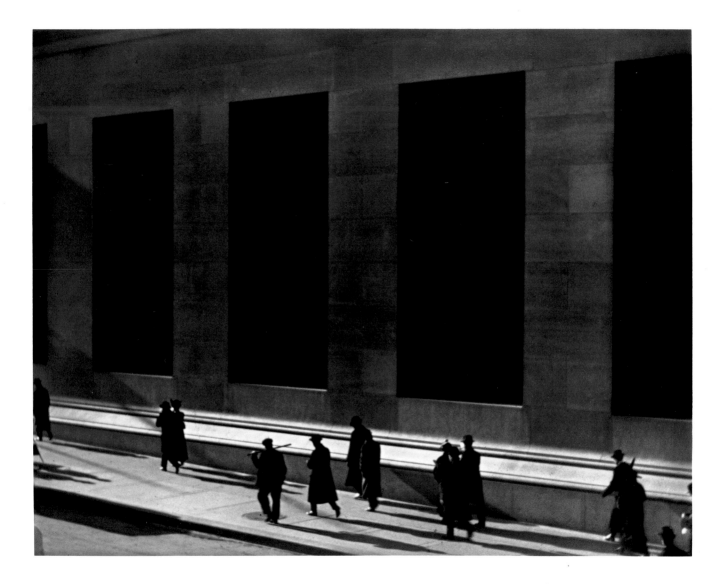

PAUL STRAND

With an Essay by Mark Haworth-Booth

MASTERS OF PHOTOGRAPHY

APERTURE

Printed in Hong Kong
10 9 8 7 6 5 4

Library of Congress Control Number: 87-70204
Hardcover ISBN 978-0-89381-746-6
Paperback ISBN 978-0-89381-259-1

Aperture Foundation books are available in North America through:
D.A.P./Distributed Art Publishers
155 Sixth Avenue, 2nd Floor
New York, N.Y. 10013
Phone: (212) 627-1999
Fax: (212) 627-9484

Aperture Foundation books are distributed outside North America by:
Thames & Hudson
181A High Holborn, London WC1V 7QX, United Kingdom
Phone: + 44 20 7845 5000, Fax: + 44 20 7845 5055
Email: sales@thameshudson.co.uk

aperturefoundation
547 West 27th Street
New York, N.Y. 10001
www.aperture.org

The purpose of Aperture Foundation, a non-profit organization, is to advance photography
in all its forms and to foster the exchange of ideas among audiences worldwide.

Among the great photographers of the twentieth century, Paul Strand truly embodied the aspirations and spirit of his age. From 1915 to 1975 he created photographs that continue to deepen in value and intensity. Their significance derives from a concentration of essentials—purity, passion, and precision—in a form that sustains these qualities as a lasting inheritance.

Paul Strand was born in New York City in 1890 and as a boy studied photography under Lewis Hine at the Ethical Culture School. As a young man he absorbed the principles of the Photo-Secession and Cubist movements. By 1915 he had moved on to experimental work of his own, which, as Alfred Stieglitz immediately recognized, redefined the boundaries of photography. His mature work extended to include film, notably *The Wave* and *Native Land,* through which he expressed radical interpretations of crisis in Mexico and the United States. After World War II he published a series of remarkable books. These studies—photographed from New England to the Outer Hebrides, from France to Ghana—defy simple description; each succeeds in transmitting the spirit of a time, a place, and a people. Major exhibitions during the 1970s confirmed his international reputation. Among Strand's final projects was a series of photographs drawn from his garden at Orgeval, France, which show that great themes can be renewed through still life. He died at Orgeval in 1976.

From 1915 to 1917, Paul Strand broke through convention with pictures that reflect the vitality, together with the degradation, he witnessed on the streets of New York. His 1916 portraits are as casual as snapshots, as compelling as the movie close-ups they suggest, and, like calotypes by David Octavius Hill and Robert Adamson, awesome in their physical presence. The great symbol that emerged from this period is *Blind Woman* (1916). In its force and complexity, this picture surpasses the social realism of Ashcan School paintings and street descriptions by Theodore Dreiser. The portrait conveys *qualities*: endurance, isolation, the curious alertness of the blind or nearly blind, and a surprising beauty in the strong, possibly Slavic, head. The whole concept of blindness is aimed like a weapon at those whose privilege of sight permits them to experience the picture, much like the "dramatic irony" in which an all-knowing audience observes a doomed protagonist onstage. Although he excluded bystanders from the picture, Strand included everyone who sees it. This extraordinary device gives the photograph its

particular edge, adding new meaning to a simple portrait.

Like *Blind Woman,* the equally celebrated *The White Fence* (1916) goes beyond its subject matter. With this photograph, Strand made the ethereal Photo-Secession style obsolete. The Photo-Secessionists leaned toward Impressionist recessiveness; their finely graduated tones seem to shroud all phenomena before World War I in a dissolving mist. The style is seen at its best in Edward Steichen's dream pools. When Strand began his career, its sensibilities dominated fine art photography.

The most rhetorical of Strand's photographs, *The White Fence* acts as a visual metaphor of inescapable precision. Strand knew his enemy well—after all, as he later wrote, he had himself "Whistlered" with a soft-focus lens. Faced with these visual satisfactions, Strand chose almost entirely to bar entrance to his photograph. The fence is no less than a fence. The light in this picture resembles twilight, announcing the death of an old style and the birth of a new constructive day. With *The White Fence,* Strand announced his view of realism as an approach that builds the world in cleanly jointed planes and actively confronts the viewer. Rather than a floating atmospheric scene, *The White Fence* is the American grain in dynamic close range. Strand revises space—from an unbroken extension leading to reverie to a place in which matter assumes vital substance and reality. Briefly imagined as piano keys, the slats of his picket fence play the opening chords of an abrasive new music. Because they erect a barrier between two worlds, *Blind Woman* and *The White Fence* demand something more of the viewer than mere observation: they require not only participation but self-reflection.

Strand's photographs function well as photogravures in Stieglitz's periodical *Camera Work* and in *The Mexican Portfolio* and as gravure and lithographic reproductions in his books; but his original prints give us something more, a vitality whose origins are ultimately indefinable. We can sense their "life" but only guess at the craftsmanship that produced them. Strand's darkroom methods were direct, sometimes complex and inventive; and always he balanced his acute sensitivity with tact. While most photographs seem modeled in putty, Strand's are the equivalent of casts in bronze. None of the photographs in this book could be called, except in a general sense, black and white. Strand insisted on greater accuracy, greater depth.

For Strand, technical prowess functioned as a kind of justice toward his subject, his medium, and himself. His choice of subject is an act of metaphor, of raising common humanity, common sights, and common methods to a higher power. With compassion he converted the customarily demotic medium of photography to a profound role. This is particularly clear in the portraits. It is as if Strand wished to cast a cloak of protection around vulnerable beings through the magic of his art. He achieved such magic by long discipline, by finally mastering an extended range of middle tones almost unique in twentieth-century photography. Not merely a technical matter, the range of tone guarantees the substance of *Mr. Bennett* (1944) and the *Young Boy* (1951). The portraits are as solid as they are vivid, recalling fifteenth-century Flemish

portraits in their ability to convey living human presence and the breadth of humanity for which Strand worked.

The iconoclastic vigor of Strand's imagery is matched and balanced by his care for what is fragile. This quality is particularly memorable in *Camargue* (1951), in which a fisherman works a landscape as intricate as his nets. There is also the view of a township in the exposed territory of the Gaspé at the gulf of the Saint Lawrence River. The Gaspé offered Strand a vision of man's vulnerability in the precarious space between a volatile sky and ocean. A specifically northern light envelops the net-drying sheds and the settlement, a church its jewel. Travelers report that the delicately balanced order described in this image has broken down, as it has in other fishing communities on both sides of the Atlantic. The photograph of a single moment has become an elegy for many places and many times.

Typical of Strand's prints is an inclusive, silvery cast, which unifies the image field. This mysterious texture is the interior subject of his still-life details from the natural world, from *Iris* (1928) to the Orgeval garden photographs made at the end of Strand's life. What could be more transitory or more marvelous than these momentary but also momentous forms? In Strand's prints they are chiaroscuro dramas of growth and being in the world. What havoc these scenes sometimes play with the sense of scale. In a short but immense poem the Yugoslavian Vasko Popa describes a snail venturing out under the stars after a rainstorm. Suddenly the poet understands that the snail's cosmos is as vast as King Lear's. He watches the creature's perilous advance with suspense and sees its silver trail lit by stars. "Bequeath to me," he exclaims, "the wonderworking towel of silver" (*Collected Poems*, 1978).

Paul Strand took infinitely great pains to preserve the wondrous fragility of the world in his work. His sense of others was detailed and panoramic. When he was a student at the Ethical Culture School, Frank Manny, the principal, sought to instill in his pupils the same regard for contemporary immigrants as for the Pilgrims who landed at Plymouth Rock. The lesson was one that Strand never forgot. In *Time in New England* (1950), the book that he compiled with Nancy Newhall, an iris—so pure and strong, first cousin to the flowers of Georgia O'Keeffe—stands opposite touching words, impure in grammar but nothing else, from the letters of Sacco and Vanzetti. Strand's sense of others expands our own.

Strand once called photography "the symbol of a great impersonal struggle," a "symbol of all young and new desire." His photographs are symbols rooted in the world. They show us that abstract qualities are implanted there by culture. Justice and desire burn in faces, foliage, and even a fence. As in all great art, the photographs of Paul Strand transcend their own immediacy, a feat of eloquence that makes their presence enduring.

MARK HAWORTH–BOOTH
Curator of Photography,
Victoria and Albert Museum, London

Abstraction, Porch Shadows, Twin Lakes, Connecticut, 1916

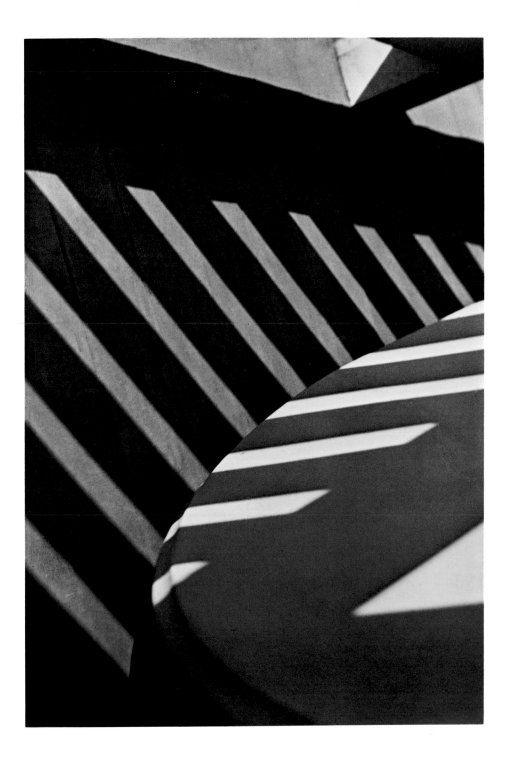

City Hall Park, New York, 1915

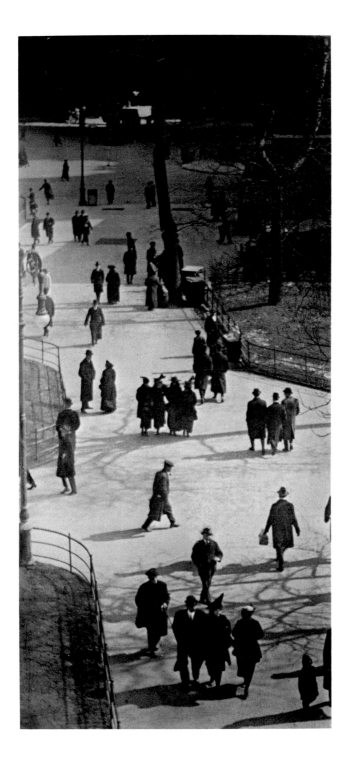

Blind Woman, New York, 1916

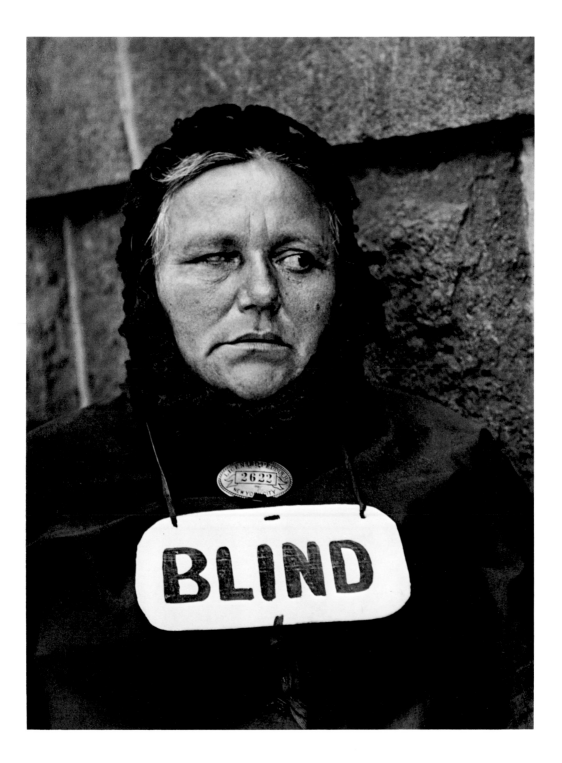

13

From the Viaduct, New York, 1916

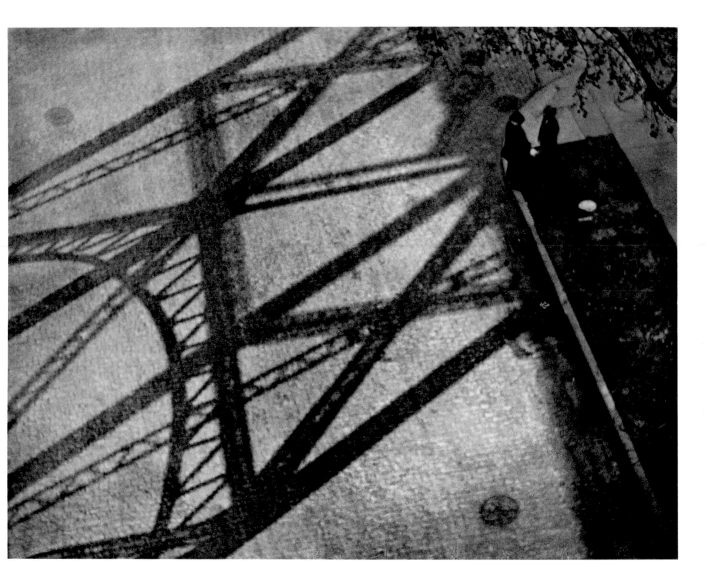

Still Life, Pear and Bowls, Twin Lakes, Connecticut, 1916

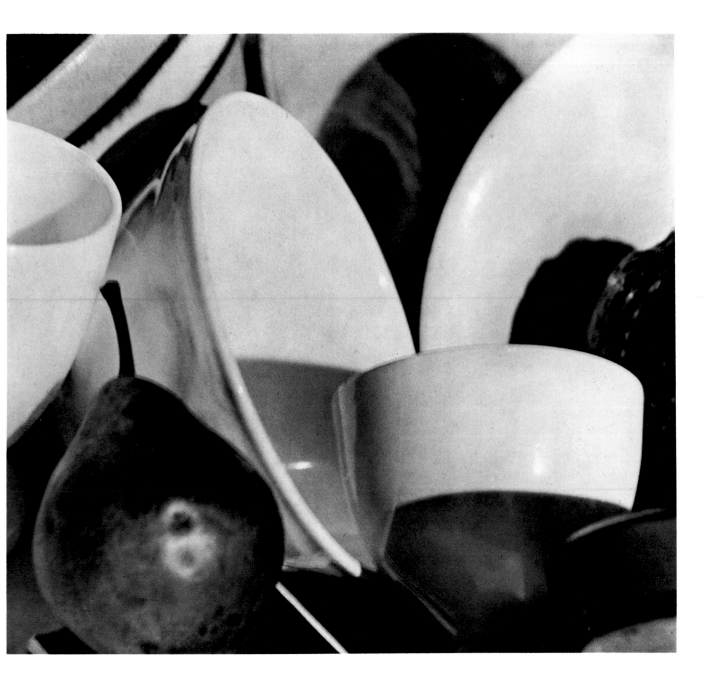

The White Fence, Port Kent, New York, 1915

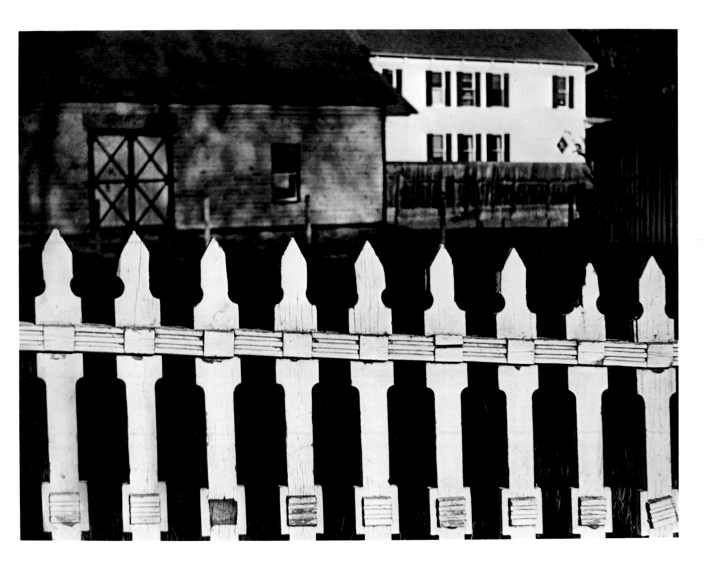

Akeley Motion Picture Camera, New York City, 1922

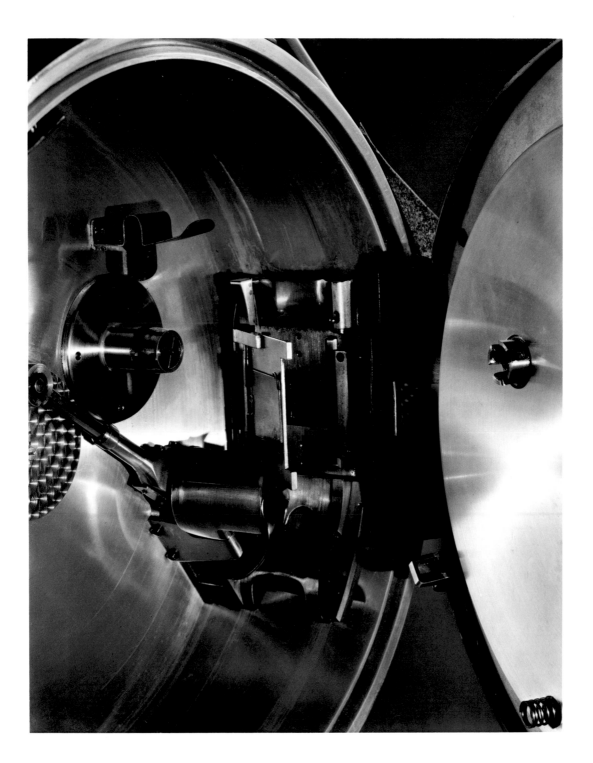

Mr. Bennett, Vermont, 1944

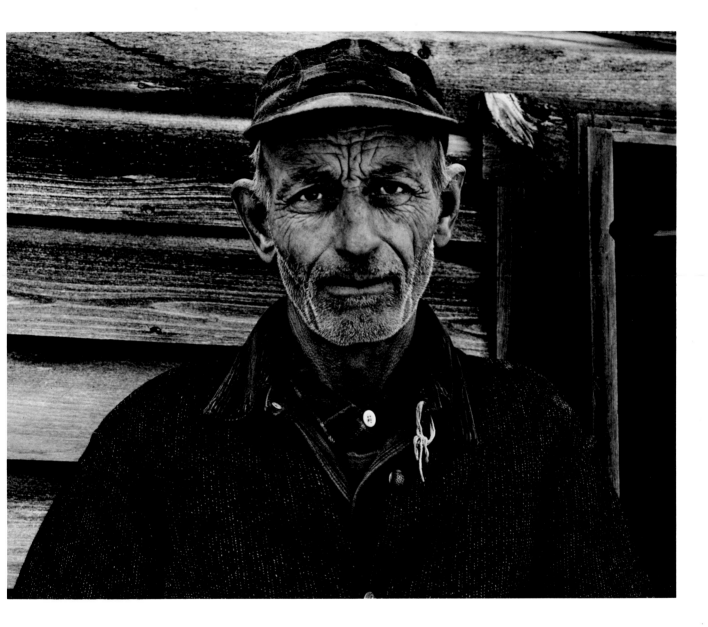

Iris, 1928

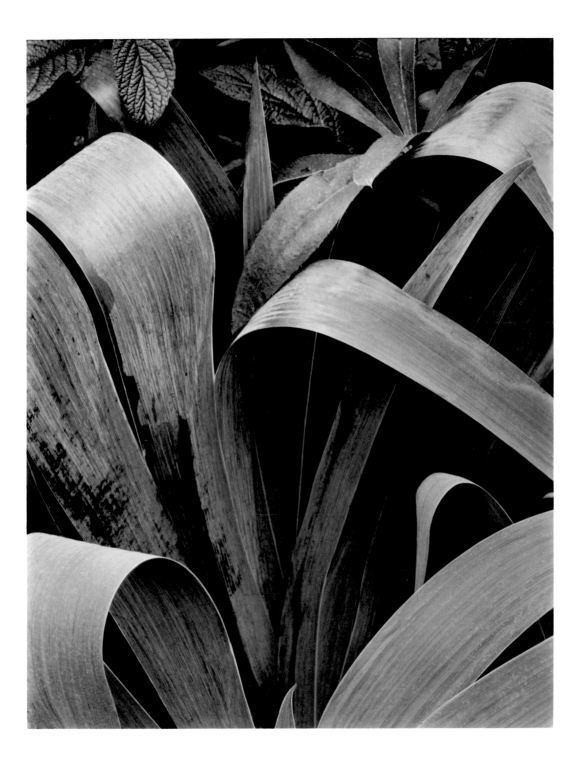

Rebecca, New York City, 1922

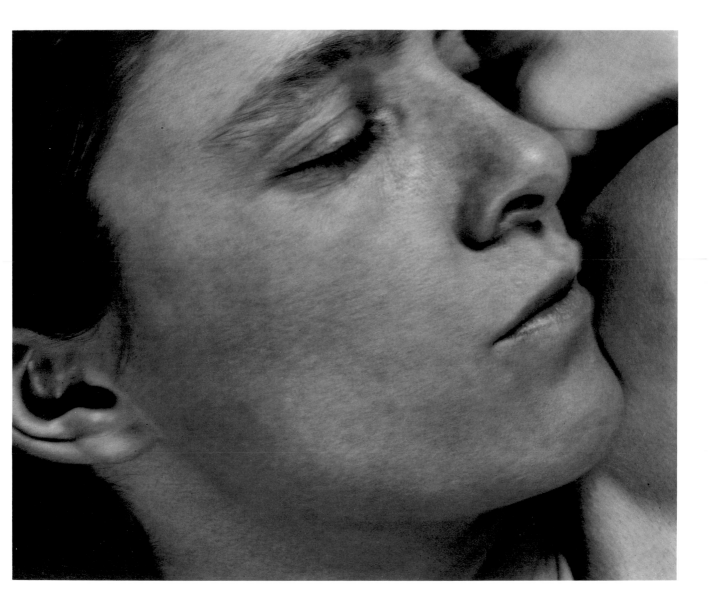

Toadstool and Grasses, Georgetown, Maine, 1928

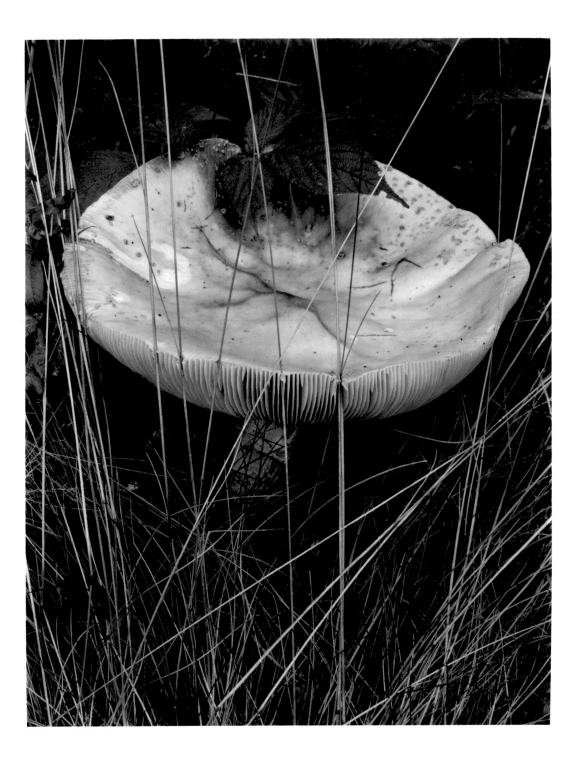

Alfred Stieglitz, Lake George,1929

Women of Santa Anna, Mexico, 1933

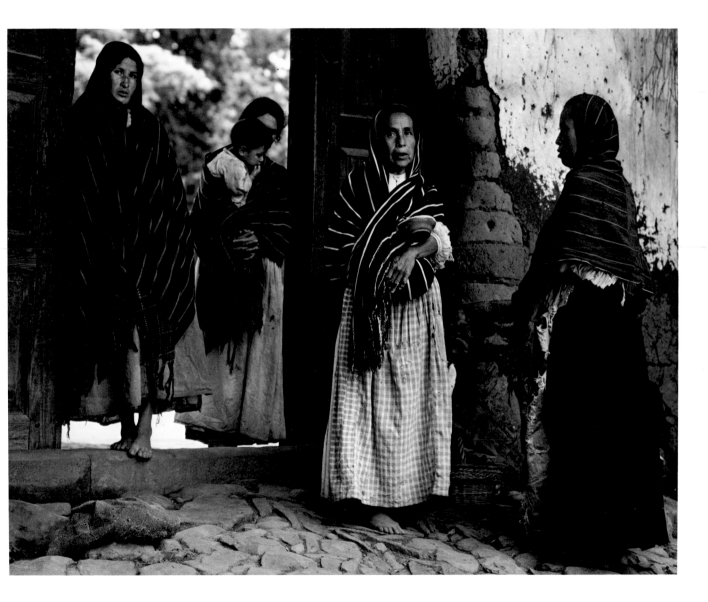

33

Boy, Hidalgo, Mexico, 1933

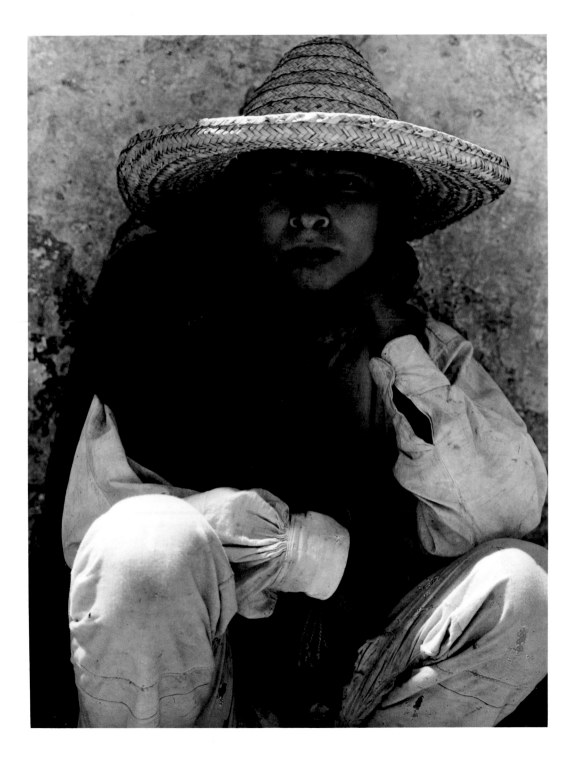

Plaza, State of Pueblo, Mexico, 1933

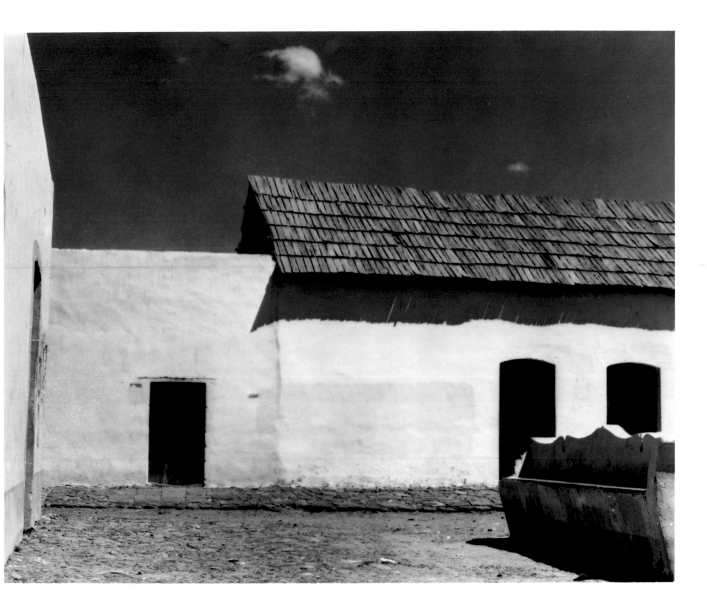

Man, Tenancingo, Mexico, 1933

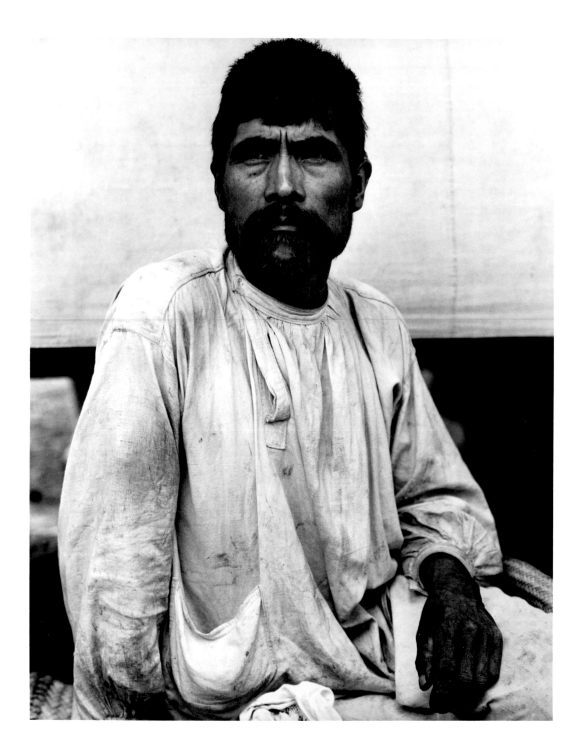

Ranchos de Taos Church, New Mexico, 1931

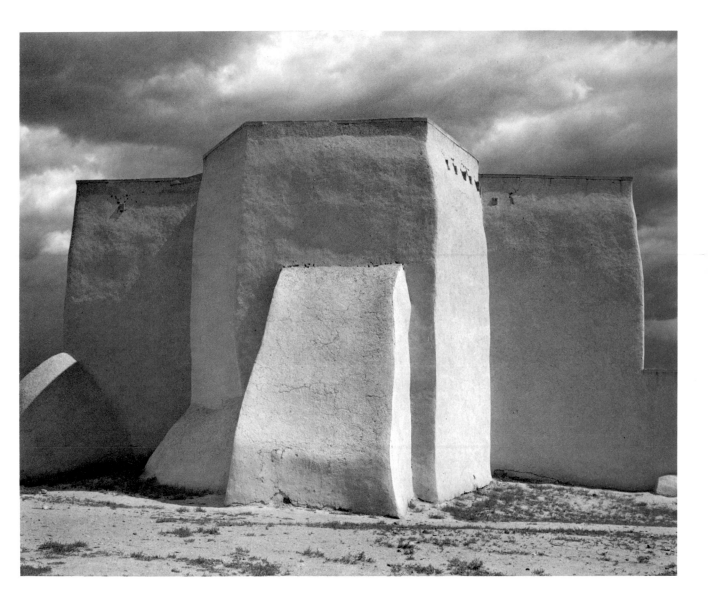

White Horse, Ranchos de Taos, New Mexico, 1932

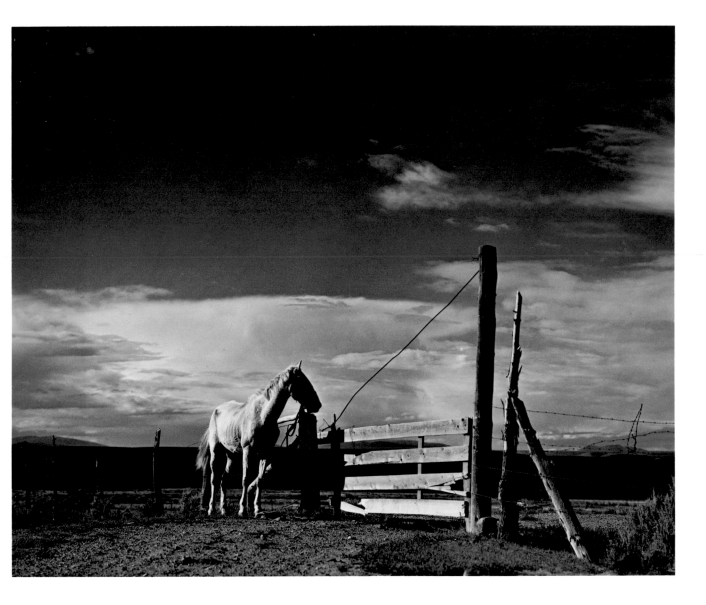

Fox River, Gaspé, 1936

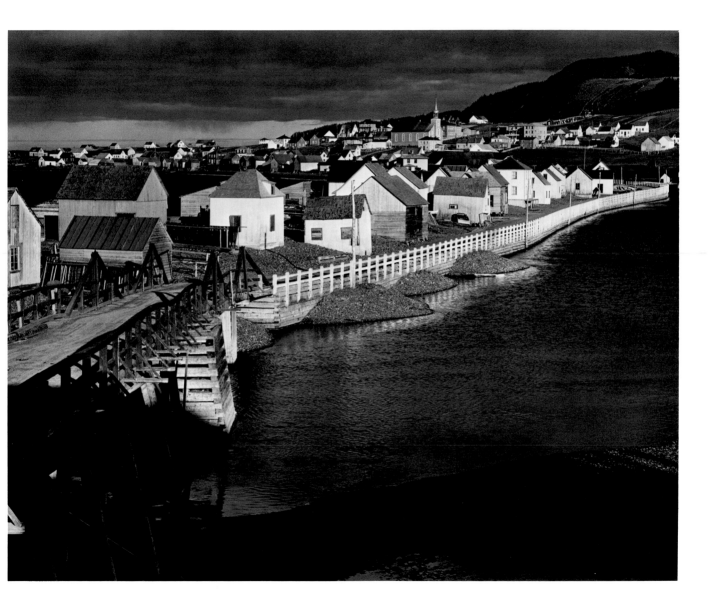

Susan Thompson, Cape Split, Maine, 1945

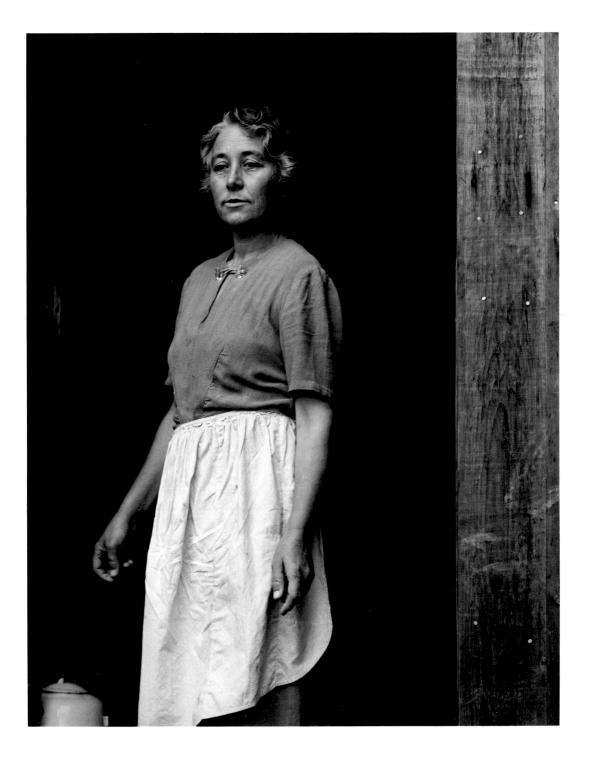

Town Hall, New Hampshire, 1946

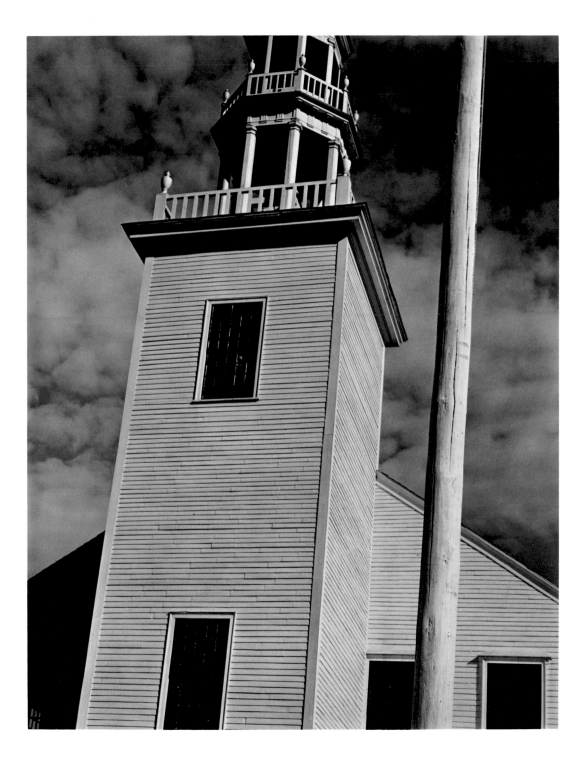

Young Boy, Gondeville, Charente, France, 1951

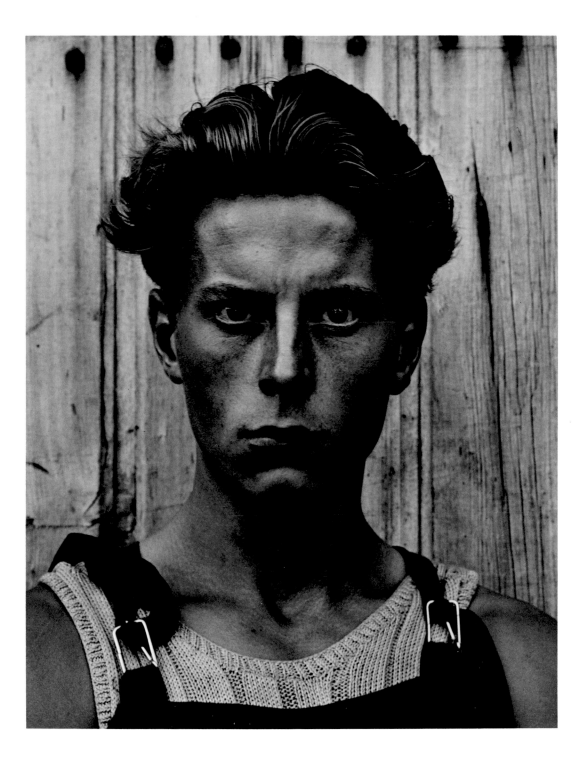

51

The Camargue, France, 1951

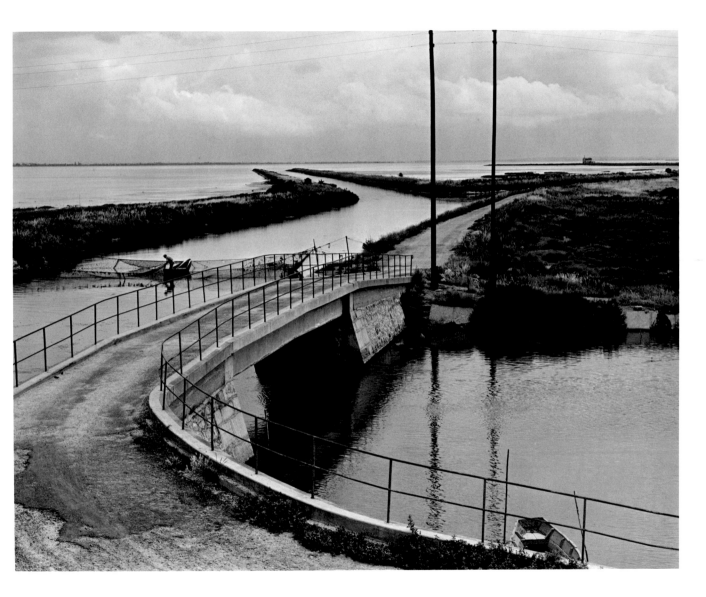

Shop, Le Bacarès Pyrénées-Orientales, France, 1950

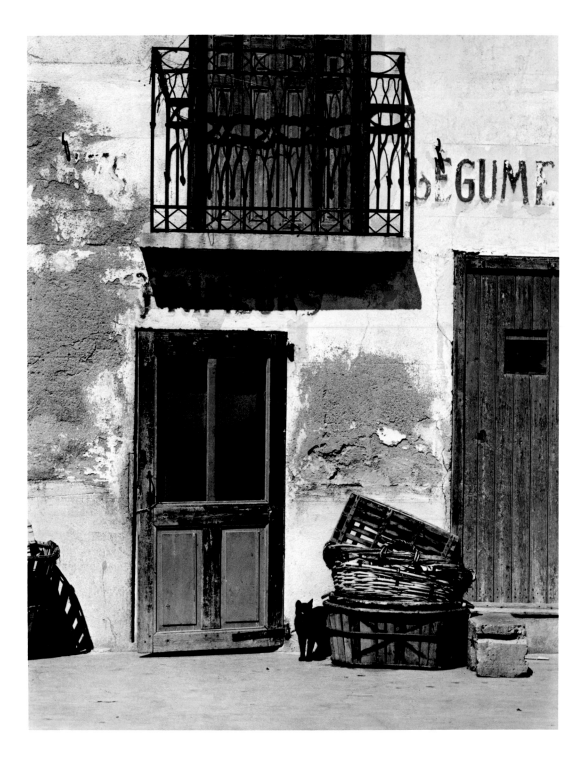

Market Day, Luzzara, Italy, 1953

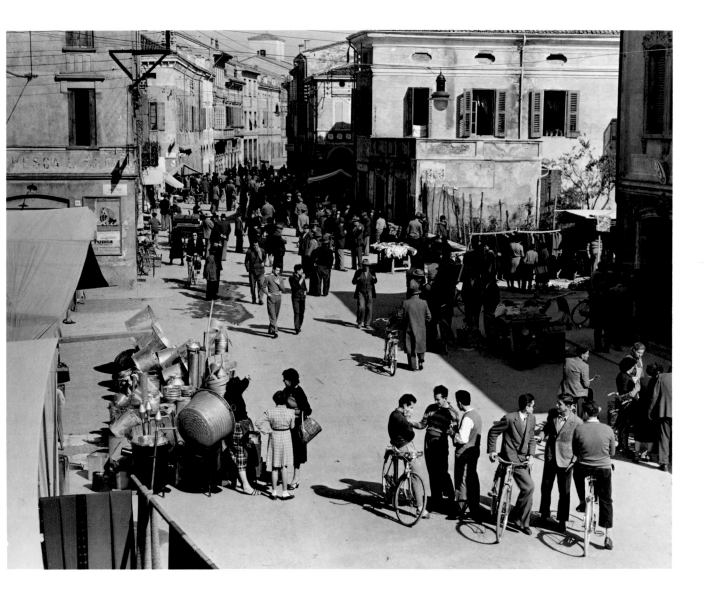

Tailor's Apprentice, Luzzara, Italy, 1953

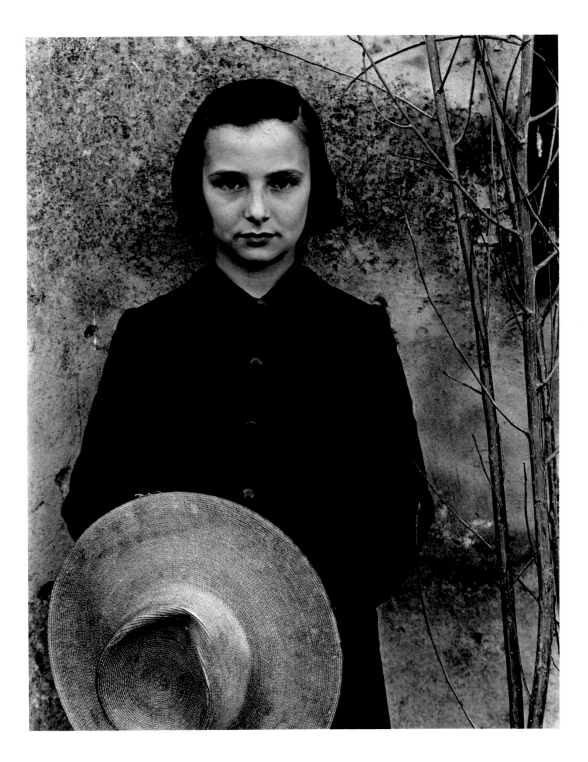

Landscape, Sicily, Italy, 1954

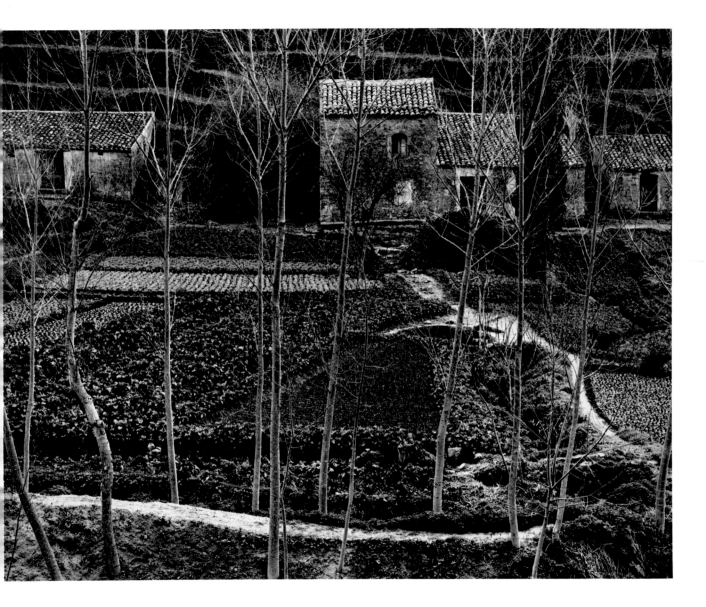

Postmistress and Daughter, Luzzara, Italy, 1954

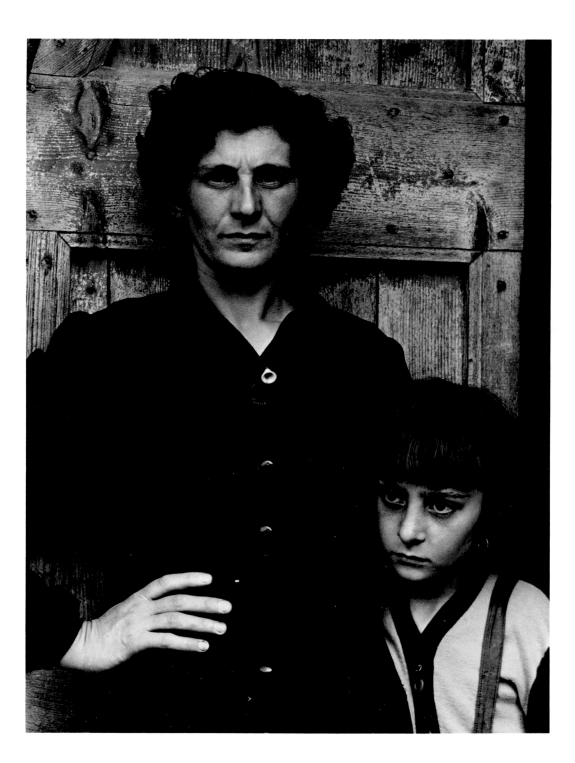

Tir a'Mhurain, South Uist, Hebrides, 1954

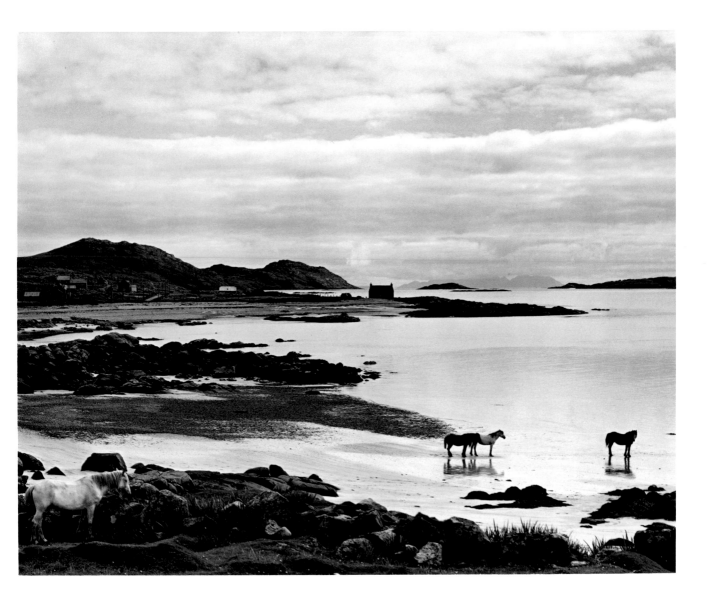

Ewan Macleod, Hebrides, 1954

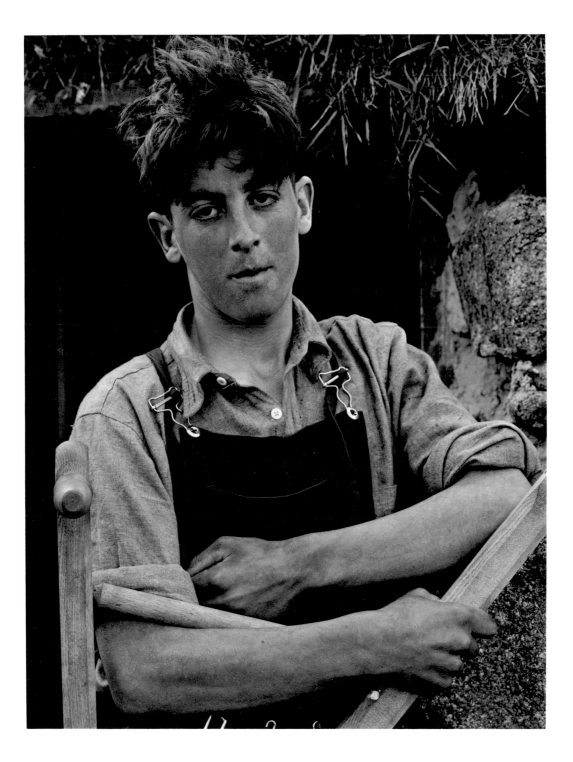

Crocuses and Primroses, Orgeval, France, 1957

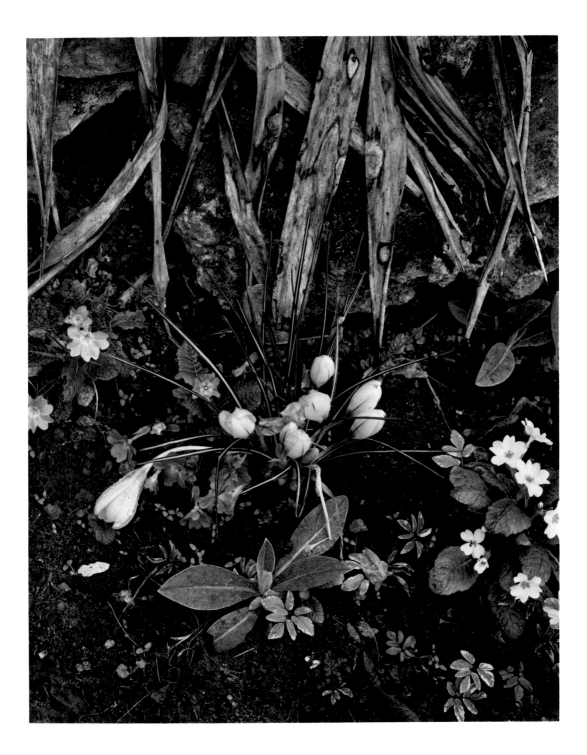

Driveway, Orgeval, France, 1973

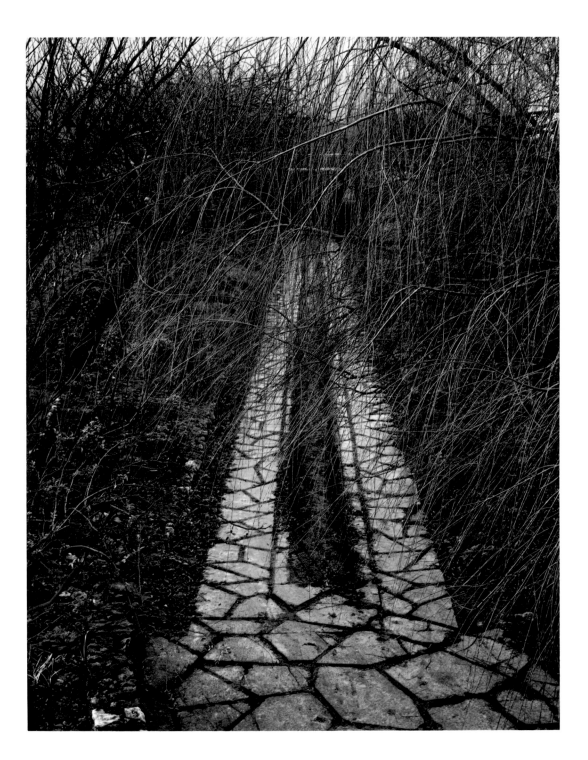

Georges Braque, Varangéville, France, 1957

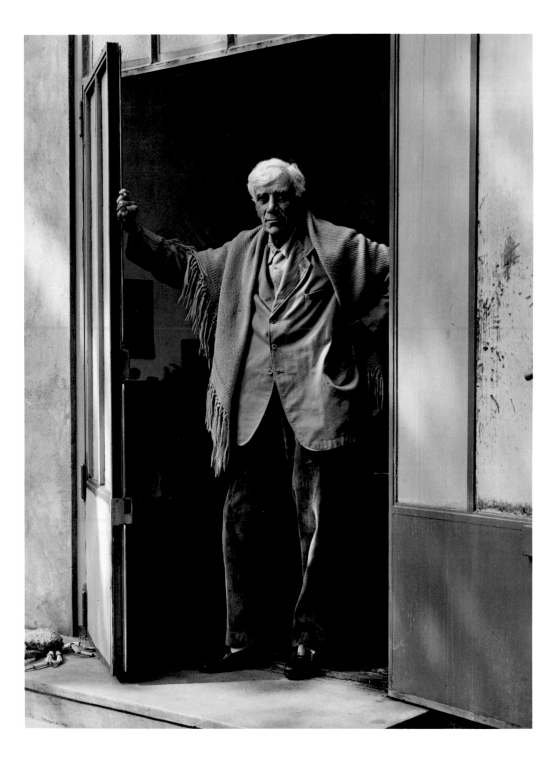

Water Wheel and Colossi, Gurna, Upper Egypt, 1959

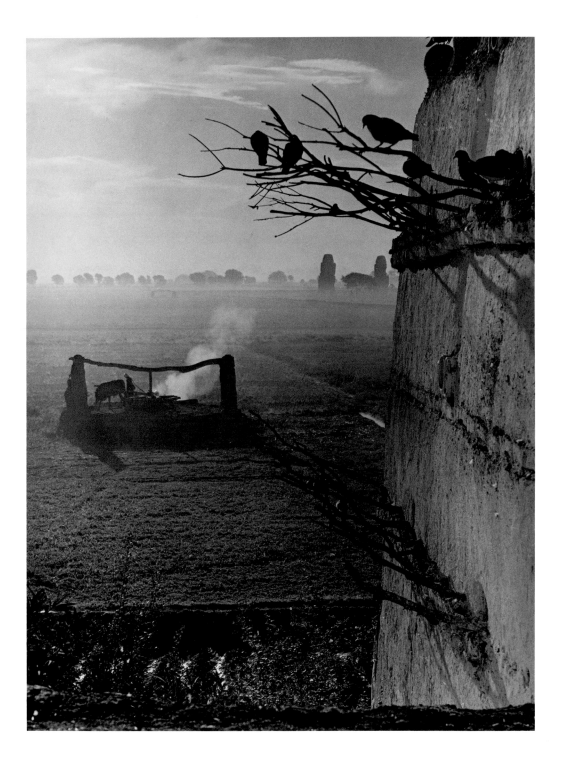

Sheik Abdul Hadi Misyd, Attar Farm, Delta Egypt, 1959

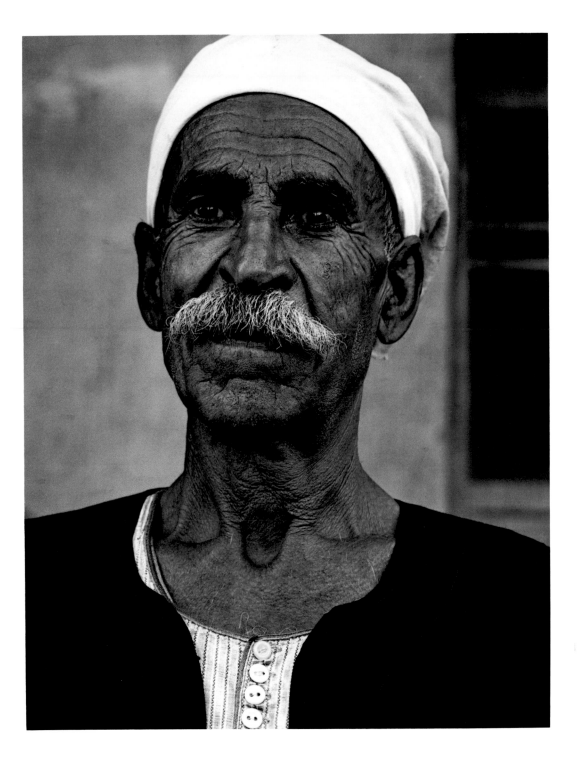

Boys at Cape Coast, Ghana, 1963

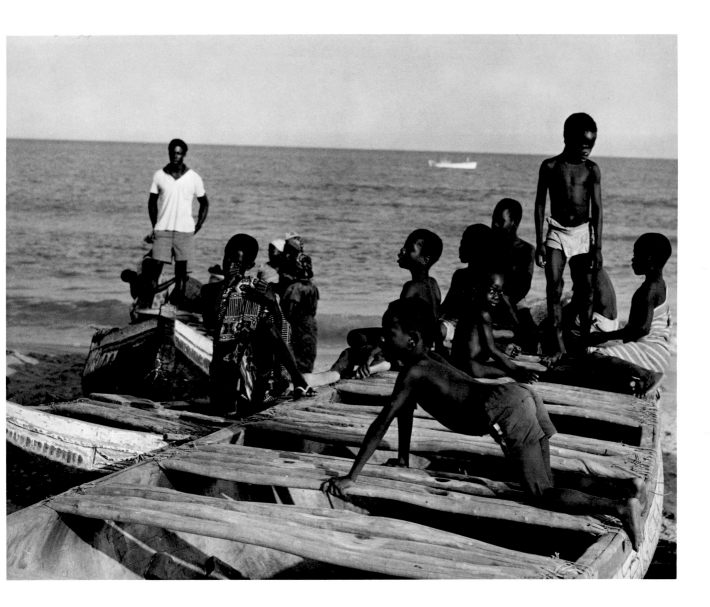

Oil Refinery, Tema, Ghana, 1963

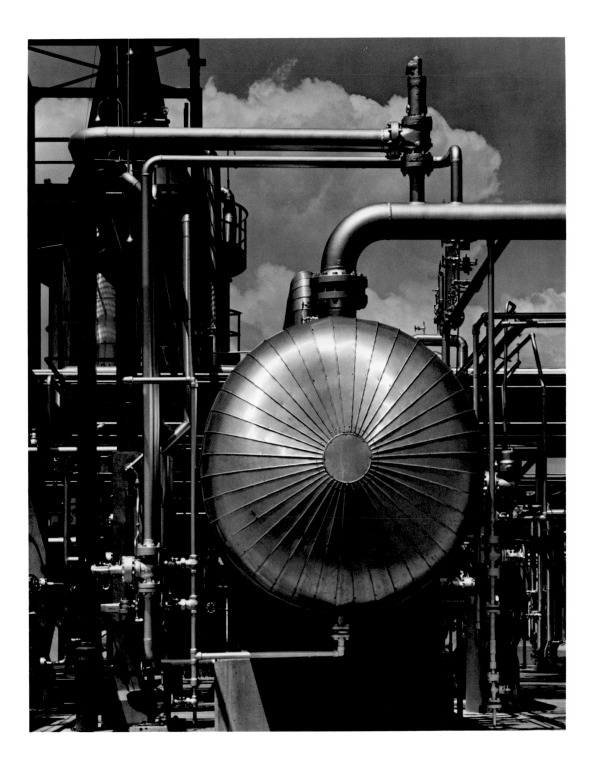

Day of the Dead, Tilisca, Rumania, 1967

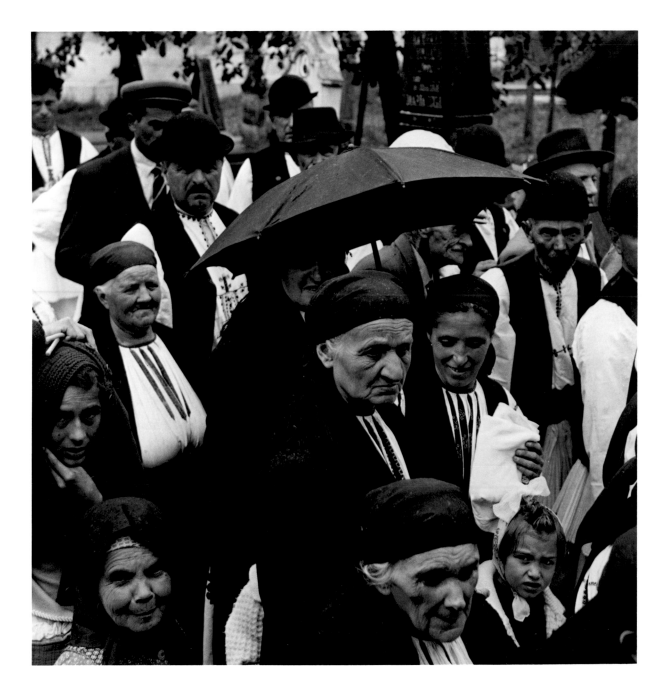

Couple, Rucar, Rumania, 1967

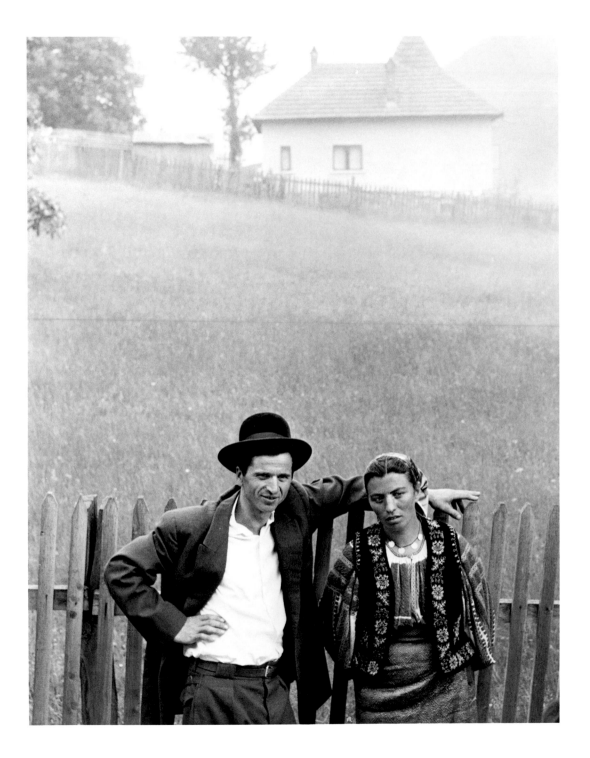

Iris and Stump, Orgeval, France, 1973

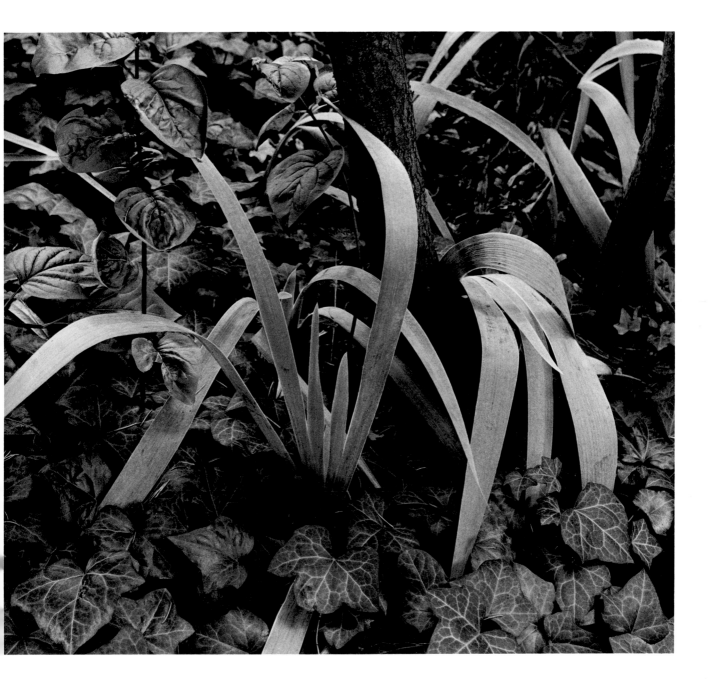

BRIEF CHRONOLOGY

1890. Born in New York City of Bohemian descent.

1907. At Ethical Culture High School, joined the class of Lewis Hine, who took his class to the Little Galleries of the Photo-Secession at 291 Fifth Avenue.

1909. Graduated Ethical Culture School. Continued photographing on weekends, and joined the New York Camera Club.

1911. First glimpse of Europe during a brief journey.

1912. Set up as commercial photographer. Experimented with soft-focus lenses, gum prints, enlarged negatives.

1913–14. Occasional visits to the Photo-Secession to see exhibitions and to show photographs to Stieglitz for criticism. Began to feel the influence of Picasso, Braque, Brancusi, and others seen at 291 and the Armory Show.

1915. Brought a folio of new works to the Photo-Secession to show Stieglitz. Stieglitz accepted them enthusiastically and promised to show them at the gallery and to publish them in *Camera Work*.

1916. First publication in *Camera Work*, number 48. Close working relationship with Alfred Stieglitz. First Strand one-man show at 291, March 13–28.

1917. Publication in last issue of *Camera Work,* numbers 49–50, devoted to Strand's new works. Began close-ups of machine forms.

1918–19. In the Army Medical Corps, worked as X-ray technician at Hospital 29, Fort Snelling, Minnesota, and became interested in surgical techniques. Upon release from Army, took short trip to Nova Scotia, where he photographed his first landscapes and close-ups of rock formations.

1921. Made film, *Manhatta,* with Charles Sheeler, which was shown at Capitol Theatre in New York under title *New York the Magnificent.* Married Rebecca Salsbury.

1922. Bought an Akeley motion picture camera and began to work as freelance Akeley specialist, continuing as a free-lance movie cameraman until 1932. Continued still photographs of machines.

1923. At invitation of Clarence White, delivered lecture at the Clarence H. White School of Photography in New York, which was subsequently printed in *British Journal of Photography.*

1925. "Seven Americans" exhibition at the Anderson Galleries, New York. March 9–28, with Charles Demuth, John Marin, Marsden Hartley, Georgia O'Keeffe, Alfred Stieglitz, and Arthur Dove.

1926. To Colorado and New Mexico in summer. Photographed tree-root forms and Mesa Verde cliff dwellings.

1927–28. Summered at Georgetown Island, Maine, near close friends sculptor Gaston Lachaise and Madame Lachaise. Took extreme close-ups of plants, rocks, and driftwood.

1929. One-man show at The Intimate Gallery, New York, March 19–April 7. To Gaspé in the summer. First interpretation of a locality. Also Strand's first attempt to integrate a landscape, to find the relationship and unity of land and sky.

1930–32. To New Mexico in the summers. Continuation of research of the landscape problem in clouds, adobe architecture, ghost towns.

1932. Exhibited with Rebecca Strand at An American Place, New York, April. Then further work in New Mexico.

1932–34. To Mexico. Series of *bultos,* and "candid" portraits of Indians. One-man show at Sala de Arte, Mexico City, February 1933. Appointed chief of photography and cinematography, Department of Fine Arts, Secretariat of Education of Mexico. Photographed and supervised production for the Mexican government of film *Redes,* released in the United States as *The Wave.*

1935. To Moscow to join the Group Theatre directors Harold Clurman and Cheryl Crawford on a brief trip. On return to the United States, photographed with Ralph Steiner and Leo Hurwitz *The Plow That Broke the Plains,* produced for the Resettlement Administration and directed by Pare Lorentz.

1936. To Gaspé in summer. Made new Gaspé series. Married Virginia Stevens.

1937–42. President of Frontier Films, a non-profit educational motion picture production group in which Leo Hurwitz, Lionel Berman, Ralph Steiner, Sidney Meyers, Willard Van Dyke, David Wolf, and others were originally associated.

1938–40. With Leo Hurwitz edited *Heart of Spain,* first Frontier Films release. Portfolio of hand gravures, twenty photographs of Mexico, published in New York by Virginia Stevens.

1942. *Native Land* released, a Frontier Film, photographed by Strand and co-directed by Strand and Leo Hurwitz.

1943. Did camera work on films for government agencies. As chairman of the Committee of Photography of the Independent Voters Committee of the Arts and Sciences for Roosevelt, edited exhibition at Vanderbilt Gallery, Fine Arts Building, 57th Street, New York City.

1943–44. To Vermont. Return to still photography after ten years in film work.

1945. One-man show, The Museum of Modern Art, New York, April 25–June 10. Guest of President and Mrs. Roosevelt with 250 American scientists, artists, and writers at lunch in the White House and at the inaugural the following day.

1946–47. Travels in New England, working on a book with Nancy Newhall, subsequently published as *Time in New England.*

1949. Invited to Czechoslovakia Film Festival in July at which *Native Land* was awarded a prize.

1950. To France to begin work on a book subsequently published as *Le France de Profil,* text by Claude Roy.

1951. Married Hazel Kingsbury. As new book projects develop, France becomes home and center of work.

1952–53. Makes photographs of Italy—some of which were later used in *Un Paese,* text by Cesare Zavattini.

1954. To the island of South Uist (Outer Hebrides) to make the photographs for *Tir a'Mhurain, Outer Hebrides,* text by Basil Davidson.

1955–57. Worked on series of portraits of prominent French intellectuals and on close-ups of the Orgeval garden.

1956. Exhibited with Walker Evans, Manuel Alvarez Bravo, and August Sander in the exhibition "Diogenes with a Camera III," directed by Edward Steichen at The Museum of Modern Art, January 18–March 18.

1959. To Egypt for two and a half months, photographing for the book *Living Egypt,* text by James Aldridge.

1960. Brief photographic trip to Rumania.

1962. To Morocco to begin work on a series of photographs and to continue research into Arab life.

1963. Placed on the Honor Roll of the American Society of Magazine Photographers, New York, June.

1963–64. To Ghana at the invitation of President Nkrumah to make a book with text by Basil Davidson.

1965. Nancy Newhall introduces Michael Hoffman, publisher of Aperture, to Paul Strand.

1967. Award of the David Octavius Hill Medal by the Gesellschaft Deutscher Lichtbildner in Mannheim, Germany, March. Return to Rumania to complete photographs begun in 1960. Supervision of second printing of *The Mexican Portfolio* produced by Aperture for Da Capo Press.

1969. Exhibition, Kreis Museum, Haus der Heimat, Freital, Germany D.D.R. Exhibition, Museum of Fine Arts, St. Petersburg, Florida, April–May.

1969–70. One-man exhibition organized by Gilbert de Keyser and Yves Auquier for the Administration Générale des Affaires Culturelles Françaises of Belgium, shown throughout Belgium and The Netherlands.

1970. Exhibition of gravures, Stockholm, Sweden, as guest of the Swedish Photographers Association. At this same time, guest of the Swedish Film Archives, which showed *Heart of Spain, The Wave,* and *Native Land.* The Strands work with Michael Hoffman on selecting and printing photographs for the monograph and Philadelphia Museum retrospective exhibition.

1971. Retrospective exhibition, Philadelphia Museum, November 24, 1971–January 30, 1972. *Paul Strand: A Retrospective Monograph* published by Aperture in two volumes.

1972. Retrospective exhibition travels to the Museum of Fine Arts, Boston, and the City Art Museum, St. Louis.

1973. The Strands visit the U.S. for the opening of the retrospective exhibition at the Metropolitan Museum of Art in New York City and at the Los Angeles County Museum. Strand is operated on for cataracts.

1974. The Calvin Tomkins profile is printed in *The New Yorker,* September 16, 1974.

1975. Photographs in the backyard of the Fifth Street apartment in New York during the summer. Initiates with Michael Hoffman plan to print a series of portfolios. Returns to Orgeval to work on the text of a book on his garden with Catherine Duncan. Prepares and signs prints for two portfolios: *On My Doorstep* and *The Garden.*

1976. *Ghana: An African Portrait* published by Aperture. Strand dies in Orgeval, France. *On My Doorstep* and *The Garden,* two portfolios, are published.

Exhibitions since 1976

1977. **Paris-New York,** Centre Georges Pompidou, Paris.

1977. **Sessanti Anni di Fotografia,** University of Pisa, Italy.

1978. **The Hebridean Photographs,** Scottish Photography Group, Edinburgh (traveled to Aberdeen, Oxford, and Glasgow).

1979. **Target Two: Five American Photographers,** Houston Museum of Fine Arts.

1979. **Photography Rediscovered: American Photographs 1900–1930,** Whitney Museum, New York (traveled to the Art Institute of Chicago).

1980. **Photography of the 50's,** International Center of Photography, New York (traveled to the Center of Creative Photography, University of Arizona, Tucson; Minneapolis Institute of Art; California State University at Long Beach; and Delaware Art Museum, Wilmington).

1981. **Cubism and American Photography 1910–1930,** Sterling and Francine Clark, Williamstown, Massachusetts (toured in the United States).

1982. **Images of America, Precisionist Painting and Modern Photography,** San Francisco Museum of Modern Art.

1983. **The Stieglitz Years at 291 (1915–1917),** Zabriskie Gallery, New York.

1983. **Paul Strand, Fifty Photographs,** retrospective exhibition sponsored by the Southern Arts Federation (toured throughout the Southeast).

1983. **Paul Strand, Hazel Kingsbury, Gifts of Personal Remembrance,** Burden Gallery, New York.

1985. **Paul Strand, Maine Photographs,** Cape Split Place, Addison, Maine.

SELECTED BIBLIOGRAPHY

Publications

Adams, Ansel, "A Decade of Photographic Art." *Popular Photography*, 22:44–46, 158–159 (June 1948).

"An American Photographer Does Propaganda Movie for Mexico." *Life*, 2:62–65, 70 (May 10, 1937).

Bauer, Catherine, "Photography: Man Ray and Paul Strand." *Arts Weekly*, 1:193, 198 (May 7, 1932).

Berger, John, "Arts in Society: Paul Strand." *New Society* (London), March 30, 1972, p. 654–55.

_____ , "Painting—or Photography?" *The Observer Weekend Review* (London), February 24, 1963, p. 25. Reprinted as "Painting or Photography?" *The Photographic Journal*, 103:182–84 (June 1963). Reprinted as "Painting or Photography?" *Photography Annual*, 1964, New York, Ziff-Davis Publishing Co., 1963, pp. 8–10.

Brown, Milton W., "Cubist—Realism: An American Style." *Marsyas*, III: 139–160 (1943–1945). (See also his *American Painting from the Armory Show to the Depression*. Princeton, Princeton University Press, 1955).

_____ , "Paul Strand and His Portrait of People." *The Daily Compass* (New York), December 31, 1950, p. 12.

_____ , "Paul Strand Portfolio." *Photography Year Book 1963*. London, Photography Magazine Ltd. 1962, pp. xiii-xv, 36–51.

Caffin, Charles, "Paul Strand in 'Straight' Photos." *Camera Work*, 48:57–58 (1916). Reprinted from *The New York American*, March 20, 1916, p. 7.

Crowther, Bosley, *"Native Land,* Impassioned and Dramatic Documentary Film on American Civil Liberties, Presented at the World." *The New York Times*, May 12, 1942, p. 16.

Clurman, Harold, "Photographs by Paul Strand." *Creative Art* 5:735–738 (October, 1929).

Coke, Van Deren, "A Talk with Paul Strand; France, Summer 1974." *History of Photography* 4, 2 (Apr. 1980), pp. 165–69.

"Democracy Fights Back." *Popular Photography*, 10:50, 80 (February 1942).

Deschin, Jacob, "Diogenes III at Museum." *The New York Times*, January 22, 1956, p. X19.

_____ , "Fine Prints by Strand." *The New York Times*, January 18, 1953, p. X15.

_____ , "Honor for Strand." *The New York Times*, April 2, 1967, p. D29.

_____ , "Paul Strand: An Eye for the Truth." *Popular Photography*, 70, 4 (April 1972), pp. 68–73, 108–111, 176.

_____ , "Strand Portfolio Again Available." *The New York Times*, January 28, 1968, p. D35.

_____ , "Viewpoint—Paul Strand at 76." *Popular Photography*, 60:14, 16, 18, 58 (March 1967).

Doty, Robert, *Photo-Secession*, Rochester, George Eastman House, 1960, pp. 62–63.

_____ , "What Was the Photo-Secession?" *Photography* (London), 17:18–29 (January 1962).

Duncan, Catherine, "Life in Stillness: The Art of Paul Strand." *Meanjin Quarterly* (Melbourne), 28:565–69 (Summer 1969).

Evans, Walker, "Photography." *Quality*, Louis Kronenberger, ed., New York, Atheneum, 1969, pp. 178–79.

Frampton, Hollis, "Meditations Around Paul Strand." *Artforum*, 10, 6 (February 1972), pp. 52–57.

"Frontier Films." *New Theater and Film*, 4:50 (March 1937).

Gernsheim, Helmut, *Creative Photography*. London, Faber and Faber, 1962, pp. 149, 152, 160, 172, 180.

Gernsheim, Helmut and Alison, *A Concise History of Photography*. London, Thames and Hudson, 1965, pp. 191–92, 205, 212, 214.

Greene, Charles, "Paul Strand." *New Masses*, 55:30–31 (May 15, 1945).

Hammen, Scott, "Sheeler and Strand's 'Manhatta': a neglected masterpiece." *Afterimage* 6, 6 (Jan. 1979), pp. 6–7.

"Highlands and Islands." *Times Literary Supplement* (London), December 28, 1962, p. 1007.

Hill, Paul and Thomas Cooper, "Paul Strand," in *Dialogue Witth Photography*. New York, Farrar, Strauss & Giroux, 1979, pp. 1–8.

"Honoring Humanity, Paul Strand." *Documentary Photography*, Life Library of Photography, Time-Life Books, New York, 1970, pp. 132–37.

"The Importance of 'When.'" *The Art of Photography*. Life Library of Photography, Time-Life Books, New York, 1971, pp. 51, 113–15.

Jeffrey, Ian, "Paul Strand." *The Photographic Journal* (London), March/April 1976, pp. 76–81.

Keller, Ulrich, "An Art Historical View of Paul Strand." *Image*, 17, 4 (December 1974), pp. 1–11.

Kleinholtz, Frank. "Paul Strand: Radio Interview." *American Contemporary Art*, 2:10–13 (May–June 1945).

Koch, Robert, "Paul Strand/Tir a'Mhurain: Outer Hebrides." *Aperture*, 11:80–81, No. 2 (1964).

Kramer, Hilton, "A Master of the Medium." *The New York Times*, December 5, 1971.

"L'oeuvre de Paul Strand." *Le Nouveau Photocinéma* (Paris), October 6, 1972, pp. 50, 65–69, 106.

Mann, Margery, "Two by Strand: When the People Draw a Curtain." *Popular Photography*, 65:90–91, 126 (December 1969).

Martin, Marcel and Marion Michelle, "Un humaniste militant Photographe et Cinéaste." *L'Ecran* (Paris), March 1975, pp. 36–45.

Mayer, Grace M., "Paul Strand's Tir a'Mhurain." *Infinity*, 12:21–23, 27 (April 1963).

McCausland, Elizabeth, "For Posterity." *Photo Technique*, 3:40–42 (January 1941).

——— , "Paul Strand's Photographs Show Medium's Possibilities." *Springfield Sunday Union and Republican*, April 17, 1932, p. 6E.

——— , "Paul Strand's Series of Photographs of Mexico." *Springfield Sunday Union and Republican*, July 7, 1940, p. 6E.

——— , "Paul Strand Turns to Moving-Pictures." *Springfield Sunday Union and Republican*, September 6, 1936, p. 5C.

McIntyre, Robert L., "The Vision of Paul Strand." *PSA Journal*, 38, 8 (August 1972), pp. 18–21.

Mellquist, Jerome, "Paul Strand's Portfolio." *The New Republic*, 103:637–38 (November 4, 1940).

——— , "Wine from These Grapes." *The Commonweal*, 33:147–50 (November 29, 1940).

Naar, Jon, "If the Photographer is Not a Discoverer, He is Not an Artist." *Infinity*, February 1973, pp. 7–14.

Newhall, Beaumont, *The History of Photography*. New York, The Museum of Modern Art, 1964, pp. 114, 117–21, 130–31, 196, 198 (See also earlier editions.)

——— , "Paul Strand, Traveling Photographer." *Art in America*, 50:44–47 (Winter 1962).

Newhall, Beaumont and Nancy, "Letters from France and Italy: Paul Strand." *Aperture*, 2:16–24, No. 2 (1953).

——— , "Paul Strand." *Masters of Photography*, New York, George Braziller, 1958, pp. 102–17. Reprinted in *Fotografia* (Prague), 8:202–04 (June 1960).

——— , "Paul Strand, Catalyst and Revealer." *Modern Photography*, 33:70–75 (August 1969).

——— , "Paul Strand: A Commentary on His New York." *Modern Photography*, 17:46–53, 103–04 (September 1953).

"Paul Strand." *American Artist*, 9:40 (October 1945).

"Paul Strand." *American Photography*, 39:60 (September 1945).

"Paul Strand." *Current Biography*, 26:40–42 (July 1965). (See also *Current Biography Yearbook 1965*, Charles Moritz, ed., New York, H. W. Wilson Company, 1965, pp. 417–19.

"Paul Strand." *Great Photographers*, Life Library of Photography, Time-Life Books, New York, 1971, pp. 150–53.

"Paul Strand, Photographer, Declines White House Bid." *The New York Times*, June 14, 1965; p. 44.

Pollack, Peter, *The Picture History of Photography*. New York, Harry N. Abrams, Inc., 1969, pp. 246, 248, 251–52, 264, 331, 530. (See also earlier edition.)

Rice, Shelley, "Paul Strand: A Life in Photography," *Lens on Campus*, 4, 2 (April 1982), pp. 22–26.

Ridge, Lola, "Paul Strand." *Creative Art*. 9:312–316 (October 1931).

Roberts, Nancy, "Historical: Paul Strand." *Photographer's Forum* 3, 1 (Nov.–Dec. 1980), pp. 21–26.

Rolfe, Edwin, "Prophecy in Stone (On a Photograph by Paul Strand)." *The New Republic*, 78:154 (September 16, 1936). Reprinted in his *First Love and Other Poems*, Los Angeles, Larry Edmonds Book Shop, 1951.

Rosenblum, Naomi, "Stieglitz and Strand." *Photographica Journal*, 3, 3 (May/June 1986), pp. 10–13.

Rosenblum, Walter, "Paul Strand." *American Annual of Photography*. Minneapolis, American Photography Book Department, 1951, pp. 6–18.

——— , Starting Your Photographic Career," Edna Bennett, ed. *Camera 35* 8:30–31, 58–62 (December 1963–January 1964).

Rotha, Paul, *Documentary Film*. London, Faber and Faber, 1936, p. 237.

Sadoul, Georges, *Le cinéma pendant la guerre, 1939–1945*. Paris, Editions Denoel, 1954, pp. 170–71.

Smith, Job, "Photography as Art." *New Masses*, 36:31 (July 9, 1940).

Soby, James Thrall, "Two Contemporary Photographers." *Saturday Review of Literature*, 38:32–33 (November 5, 1955).

Stettner, Lou, "A Day to Remember: Paul Strand Interview." *Camera 35*, October 1972, pp. 55–59, 72–74.

———, "Speaking Out: Strand Unraveled." *Camera 35*, July/August 1973, pp. 8, 67.

Stieglitz, Alfred, "Our Illustrations." *Camera Work*, 49–50:36 (June 1917).

"The Talk of the Town." *The New Yorker*, March 17, 1973, pp. 29–31.

Tomkins, Calvin, "Profiles: Look to the Things Around You." *The New Yorker*, September 16, 1974, pp. 44–94.

Tosi, Virgilio, "Una Testimonianza." *Photo 13* (Milan), 15/16, August 1972, pp. 20–25.

Turner, J. B., "Viewpoint: Paul Strand." *New Zealand Studio*, 6, 3, 1970/71, p. 8

Weiss, Margaret, "Paul Strand, Close-up on the Long View." *Saturday Review*, December 18, 1971, p. 20.

Publications By

"Address by Paul Strand." *Photo Notes*, January, 1948, pp. 1–3.

"Aesthetic Criteria." *The Freeman*, 2:426–27 (January 12, 1921). Letter to the Editor.

"Alfred Stieglitz and a Machine." New York, privately printed, 1921. Reprinted in *Manuscripts*, 2:6–7 (March 1922). Rewritten for *America and Alfred Stieglitz*, Waldo Frank et. al., eds., New York, The Literary Guild, 1934, pp. 281–85.

"Alfred Stieglitz 1864–1946." *New Masses*, 60:6–7 (August 6, 1945).

"An American Exodus by Dorothea Lange and Paul S. Taylor." *Photo Notes*, March–April, 1940, pp. 2–3.

"American Watercolors at The Brooklyn Museum." *The Arts*, 2:148–52 (December 1921).

"The Art Motive in Photography." *British Journal of Photography*, 70:613–15 (October 5, 1923). Précis of text and notes of discussion in "The Art Motive in Photography: A Discussion," *Photographic Journal*, 64:129–32 (March 1924).

"Correspondence on [Louis] Aragon." *Art Front*, 3:18 (February 1937). Comment on Aragon's "Painting and Reality," *Art Front*, 2:7–11 (January 1937).

"The Forum." *The Arts*, 2:332–33 (February 1922). Letter to the Editor in reply to one by Carl Sprinchorn in *The Arts*, 2:254–55 (January 1922), which was in response to Strand's article "American Watercolors at The Brooklyn Museum," *The Arts*, 2:148–52 (December 1921).

"From a Student's Notebook." *Popular Photography*, 21:53–56, 174, 176 (December 1947). Various quoted remarks from a lecture at the Institute of Design, Chicago.

"Georgia O'Keeffe." *Playboy*, 9:16–20 (July 1924).

"The 'Independents' in Theory and Practice." *The Freeman*, 3:90 (April 6, 1921).

"Italy and France," *U.S. Camera Yearbook 1955*, New York. U.S. Camera Publishing Corp., 1954, pp. 8–17.

"John Marin." *Art Review*, 1:22–23 (January 1922).

Kleinholtz,, Frank. "Paul Strand: Radio Interview." *American Contemporary Art*, 2:10–13 (May–June 1945). Various quoted remarks from an interview, "Art in New York," WNYC, April 25, 1945.

"Lachaise." *Second American Caravan*, A. Kreymborg et. al., eds., New York, The Macaulay Co., 1928, pp. 650–58.

"Les Maisons de la Misère." *Films*, 1:89–90 (November 1939).

"Manuel Alvarez Bravo," *Aperture*, 13:2–9. No. 4 (1968). Excerpt reprinted in *Manuel Alvarez Bravo*, by Fred R. Parker, Pasadena, Pasadena Art Museum, 1971.

"Marin Not an Escapist." *The New Republic*, 55:254–55 (July 25, 1928).

"The New Art of Colour." *The Freeman*, 7:137 (April 18, 1923). Letter to the Editor in response to Willard Huntington Wright, "A New Art Medium," *The Freeman*, 6:303–04 (December 6, 1922).

"Painting and Photography." *The Photographic Journal*, 103:216 (July 1963). Letter to the Editor in response to John Berger's "Painting—or Photography?" *The Observer Weekend Review* (London), February 24, 1963, p. 25.

"Paul Strand Writes a Letter to a Young Photographer." *Photo Notes*, Fall 1948, pp. 26–28.

"Photographers Criticized." *New York Sun*, June 27, 1923, p. 20. Letter to the Editor in response to Arthur Boughton's letter, "Photography as an Art," *New York Sun*, June 20, 1923, p. 22, which in turn was a response to an article by Charles Sheeler, "Recent Photographs by Alfred Stieglitz," *The Arts*, 3:345 (May 1923).

"Photography." *Seven Arts*, 2:524–25 (August 1917). Reprinted in *Camera Work*, 49–50:3–4 (June 1917).

"Photography and the New God." *Broom*, 3:252–58 (November 1922). Reprinted in *Photographers on Photography*, Nathan Lyons, ed., Englewood Cliffs, Prentice-Hall, Inc. 1966, pp. 138–44.

"Photography to Me." *Minicam Photography*, 8:42–47, 86, 90 (May 1945).

"A Picture Book for Elders." *Saturday Review of Literature*, 8:372 (December 12, 1931). Review of *David Octavius Hill* by Heinrich Schwarz.

"A Platform for Artists." *Photo Notes*, Fall, 1948, pp. 14–15. About the Progressive Party's plank on the arts.

"Power of a Fine Picture Brings Social Changes." *New York World-Telegram*, March 4, 1939, p. 11. Various quoted remarks concerning the making of *The Wave*.

"Realism: A Personal View." *Sight and Sound*, 18:23–26 (January 1950). Reprinted as "International Congress of Cinema, Perugia," *Photo Notes*, Spring 1950, pp. 8–11, 18.

Sabine, Lillian, "Paul Strand, New York City." *The Commercial Photographer*, 9:105–11 (January 1934). Various quoted remarks.

"El Significado de la Pintura Infantil." *Pinturas y Dibujos de los Centros Culturales*, Mexico City, Departamento del Distrito Federal, Dirección General de Acción Civica, 1933.

"A Statement." *Photographs of People by Morris Engel*, New York, New School for Social Research, 1939. Reprinted in *Photo Notes*, December, 1939, p. 2.

"Steichen and Commerical Art." *The New Republic*, 62:21 (February 19, 1930). Letter to the Editor in reference to Paul Rosenfeld's "Carl Sandburg and Photography," *The New Republic*, 62:251–53 (January 22, 1930).

"Stieglitz, An Appraisal." *Popular Photography*, 21:62, 88, 90, 92, 94, 96, 98 (July 1947). Reprinted in *Photo Notes*, July 1947, pp. 7–11.

"The Subjective Method." *The Freeman*, 2:498 (February 2, 1921). Letter to the Editor concerning various pieces by Walter Pach.

"Weegee Gives Journalism a Shot for Creative Photography." *PM* (New York), July 22, 1945, pp. 13–14.

Weiner, Sandra, "Symposium Report." *Photo Notes*, Spring 1949, pp. 8–9. Various quoted remarks.

Books and Exhibition Catalogs

Camera Work, number 48, October 1916.

Camera Work, numbers 49–50, June 1917.

La France de Profil. Text by Claude Roy. Lausanne, La Guilde du Livre, 1952. Text excerpted as "An Appreciation of Paul Strand," *U.S. Camera 1955*, New York, U.S. Camera Publishing Corp., 1954, pp. 19, 23, 26.

Ghana, An African Portrait. Text by Basil Davidson, Millerton, New York, Aperture Books, 1975.

Hill, Paul and Thomas Cooper, "Paul Strand," in *Dialogue With Photography*, New York, Farrar Straus & Giroux, 1979, pp. 1–8.

Lachaise, Gaston, *Paul Strand, New Photographs*, New York, The Intimate Gallery, 1929.

Living Egypt. Text by James Aldridge. Dresden, VEB Verlag der Kunst, 1969. Also published in London, MacGibbon and Kee, 1969, and in New York, An Aperture Book, Horizon Press, 1969. Introductory text excerpted in *Creative Camera*, 63:330–31 (September 1969).

McCausland, Elizabeth, *Paul Strand*. Springfield, privately printed, 1933.

Newhall, Nancy, *Paul Strand: Photographs 1915–1945*. The Museum of Modern Art, 1945.

Rosenblum, Naomi, *Paul Strand: The Early Years, 1910–1932*, Ann Arbor, Michigan, University Microfilms, 1978.

Rosenblum, Naomi, *Paul Strand: The Stieglitz Years at 291 (1915–1917)*, New York, Zabriskie Gallery, 1983.

Paul Strand. Brussels, L'Administration Générale des Affaires Culturelles Françaises, 1969.

Paul Strand. Foreword by Siegfried Huth. Freital, Haus der Heimat Kreismuseum, 1969.

Paul Strand: A Retrospective Monograph. One-volume and two-volume editions, with text selections from various sources. Millerton, New York, Aperture Books, 1971.

Photographs of Mexico. Foreword by Leo Hurwitz. New York, Virginia Stevens, 1940. Also published as *The Mexican Portfolio*, with Preface by David Alfaro Siqueiros, New York, produced by Aperture, Inc. for DaCapo Press, 1967.

Time in New England. With Nancy Newhall. New York, Oxford University Press, 1950, Aperture 1980.

Tir a'Mhurain. Text by Basil Davidson. Dresden, VEB Verlag der Kunst, 1962. Also published in London, MacGibbon and Kee, 1962, and in New York, An Aperture Book, Grossman, 1968.

Un Paese. Text by Cesare Zavattini. Turin, Giulio Einaudi, 1955.

Vrba, Frantisek, *Paul Strand*, Prague, Státni nakladatelstvi krásné literatury a umeni, 1961. Text also in English translation.

Fall in Movement, Orgeval, France, 1973

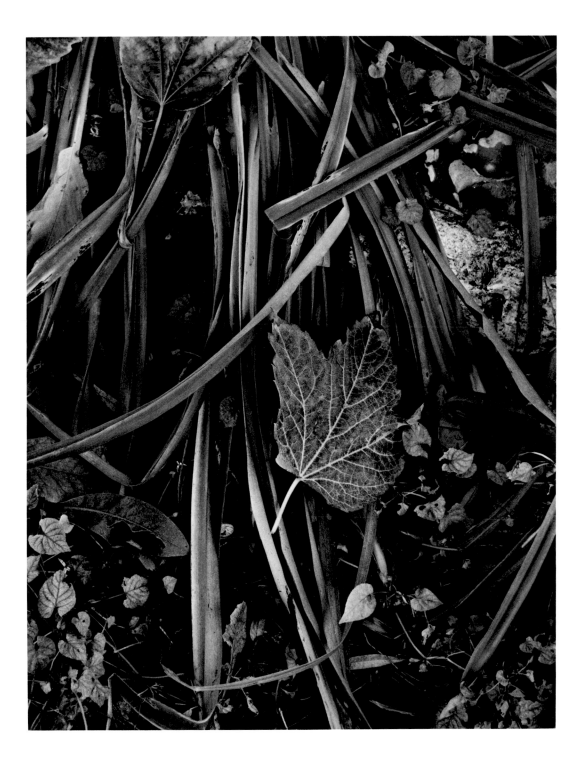